THE POCKET ANIME MOVIES

Published in 2025
by Gemini Books
Part of Gemini Books Group

Based in Woodbridge and London

Marine House, Tide Mill Way,
Woodbridge, Suffolk IP12 1AP
United Kingdom

www.geminibooks.com

Text and Design © 2025 Gemini Adult Books Ltd

Text by Roland Hall
Cover illustration by Natalie Floss

ISBN 978-1-80247-299-8

All rights reserved. No part of this publication may be reproduced in any form or by any means – electronic, mechanical, photocopying, recording or otherwise – or stored in any retrieval system of any nature without prior written permission from the copyright holders.

A CIP catalogue record for this book is available from the British Library.

Disclaimer: The book is a guidebook purely for information and entertainment purposes only. All trademarks, individual and company names, brand names, registered names, quotations, celebrity names, logos, dialogues and catchphrases used or cited in this book are the property of their respective owners. The publisher does not assume and hereby disclaim any liability to any party for any loss, damage or disruption caused by errors or omissions, whether such errors or omissions result from negligence, accident, or any other cause. This book is an unofficial and unauthorized publication by Gemini Adult Books Ltd and has not been licensed, approved, sponsored or endorsed by any person or entity.

Manufacturer's EU Representative: Eurolink Compliance Limited, 25 Herbert Place, Dublin, D02 AY86, Republic of Ireland.
admin@eurolink-europe.ie

Printed in China

10 9 8 7 6 5 4 3 2 1

MIX
Paper | Supporting responsible forestry
FSC® C020056

Picture Credits: Alamy Stock Photo: Allstar Picture Library Limited. / WALT DISNEY PICTURES 4; Photo 12 6; BFA 14; UPI 116.

THE POCKET

ANIME MOVIES

G:

CONTENTS

Introduction 6

50 Must-see Anime Movies 14

Directors' Cut 116

INTRODUCTION

Anime, technically, can be any animation from anywhere. It has developed to mean, specifically, animation from Japan. For the purposes of this book, it means long-form releases of usually cinema-length features. This specifically excludes short-form anime, which is, in turn, based on manga (Japanese graphic novels).

Covering a huge breadth of subjects, styles and emotions, anime films are born from, and continue, Japan's rich storytelling tradition. They often explore complex themes, but are grounded in human emotion, relationships between humankind and the environment, and technology and its effect on the world.

ANIME MOVIES

In the West, anime used to be perceived as an art form for children; that is far from the truth. And while yes, there are plenty of anime for children, there's actually an anime for everyone, whatever your taste. Most adults would get something from watching every movie listed on the following pages. However, some anime are dark – very dark – and have themes and scenes that make for difficult viewing.

INTRODUCTION

The best anime movies – and this book is filled with details of them – are thought-provoking, colourful, deep and meaningful. It is a good idea to find a style, a studio, a director or a subgenre you like, research it and dive deep down that rabbit hole. Because anime has been around for such a long time, there are plenty of hidden (and not so hidden) gems out there waiting for you... Good luck on your journey, and have fun.

ANIME MOVIES

"Today, all of humanity's dreams are cursed somehow. Beautiful yet cursed dreams."

— Hayao Miyazaki,
The Kingdom of Dreams and Madness, 2013

INTRODUCTION

"I do think filmmaking and dreaming have a lot in common."

— Satoshi Kon,
Montreal Mirror, 2007

ANIME MOVIES

The Family-friendly Factor

The rating system in the reviews that follow is simply an indicator of how gentle the film is to watch in a multigenerational environment, solely in the author's opinion. A mark of 5 is given to cuddly movies, where there is little jeopardy and plenty of laughs, whereas a 1 (or less) may indicate graphic violence, disturbing themes and something to give you nightmares.

Anime is associated with children because of the artistic style, but this is definitely not always the case; some have very adult themes and very disturbing scenes. Please do your own research first to avoid any potential problems.

INTRODUCTION

"Nothing that happens is ever forgotten, even if you can't remember it."

— Zeniba, *Spirited Away*, 2001

★ ★ ★ ★ ★

50 MUST-SEE ANIME MOVIES

ANIME MOVIES

① Flying Phantom Ship/The Flying Ghost Ship, 1969
Director: Hiroshi Ikeda
Runtime: 60 mins
Family-friendly factor: 4/5

This film is notable for the purist as being one of the early animation jobs by the now legendary Hayao Miyazaki. It's also notable for general viewers for being an interesting movie about a boy and his dog solving a mystery (with the aid of the superbly named Captain Phantom) and encountering all sorts of monsters.

The movie was rereleased in 2022 with a new English-language dub, showing its enduring popularity and importance in the pantheon of animated features.

50 MUST-SEE ANIME MOVIES

"Were they selling any of those giant sea monsters as weapons?"

— Hayato

ANIME MOVIES

"It has become my nature to fight without fear of death."

— **Chirin**

② Ringing Bell, 1978
Director: Takashi Yanase
Runtime: 47 mins
Family-friendly factor: 2/5

Chirin is a happy, fluffy little lamb, frolicking around the grassy valley under blue, cloudy skies and enjoying his family's company. Until the feared Wolf King ventures into the barn at night... From that point, the entire movie transforms from sweetness and light to dark – very dark. It becomes a fascinating tale of strength, revenge and human nature (yes, in sheep). An odd tale by Western standards, but a fascinating watch.

③ Taro the Dragon Boy, 1979
Director: Kiriro Urayama
Runtime: 75 mins
Family-friendly factor: 4/5

Adapted from an ancient Japanese folk tale, *Taro the Dragon Boy* has a distinctive fairy-tale aspect. Taro, a lazy youth, is given a magic potion by a *tengu* (a wizard he meets in the woods while teaching the animals to wrestle) that gives him super strength, but it only works when he is helping others. A complicated story ensues, the basis of which is Taro's search for his mother.

You can see the influence this superb-looking movie has had on subsequent ones, and it is a fascinating insight into Japanese culture – well worth sticking with.

50 MUST-SEE ANIME MOVIES

"Taro, hold on to my horns as tightly as you can."

— **The Dragon**

ANIME MOVIES

④ Barefoot Gen, 1983
Director: Mori Masaki
Runtime: 85 mins
Family-friendly factor: 0/5

It starts as it goes on: a bombing raid, flames and destruction. A gritty, child's-eye view of the end of World War II in Hiroshima, *Barefoot Gen* is fascinating for its view-from-the-other-side aspect. It isn't common to see how the Japanese treat this era in their history, giving this movie extra depth. It is a bleak view of a bleak time. Don't let the fact that it's a cartoon fool you into thinking it treats the subject matter delicately.

50 MUST-SEE ANIME MOVIES

"They'll never bomb us, we're too boring."

— Gen Nakaoka

ANIME MOVIES

"After a thousand years of darkness, he will come, clad in blue and surrounded by fields of gold, to restore mankind's connection with the Earth that was destroyed."

— Obaba

⑤ Nausicaä of the Valley of the Wind, 1984
Director: Hayao Miyazaki
Runtime: 117 mins
Family-friendly factor: 4/5

This movie is based on the manga that was created by Miyazaki a few years before. *Nausicaä* is Studio Ghibli before it was Studio Ghibli, produced by Isao Takahata and directed by Miyazaki. It now appears under their banner, although the studio didn't exist when it was made.

A post-apocalyptic tale of the brave Princess Nausicaä, it's a good-versus-evil tale with a strong environmental bent that was ahead of its time. It's a great story, beautifully illustrated and very well told. There have been various versions released, notably the heavily cut one from the 1980s, which is not worth viewing. Make sure you get the "full-fat" movie that was redubbed and released by Disney in 2005.

⑥ Night on the Galactic Railroad/Night Train to the Stars, 1985
Director: Gisaburo Sugii
Runtime: 113 mins
Family-friendly factor: 1/5

This is an odd one: ostensibly a tale about a couple of cats, Giovanni and Campanella, on a mysterious train journey through the stars. However, it's very much not that simple (assuming that sounded simple!), and as the journey continues it becomes apparent that things are darker and a lot more serious than they first seem...

It's a (very) long train ride away from *The Polar Express*, 2004, and without providing a spoiler, don't expect a happy ending, let alone a happy journey.

50 MUST-SEE ANIME MOVIES

"I don't know how to explain it; but I think that people are happiest when they do something truly good!"

— Campanella

ANIME MOVIES

⑦ Castle in the Sky/ Laputa: Castle in the Sky, 1986
Director: Hayao Miyazaki
Runtime: 124 mins
Family-friendly factor: 5/5

The very first official outing of the legendary Studio Ghibli is a good one, although it is a rather strange steampunk mashup of pirates, a magical floating island, northern English mining and environmentalism – all told through the eyes of two children.

However, it is beautifully animated and has a solid moral core. Joe Hisaishi provides a pulsing soundtrack, ensuring all the senses are captivated by this extraordinary story.

50 MUST-SEE ANIME MOVIES

"Laputa will live. I will return it to life! Laputa's power is the dream of all mankind!"

— **Colonel Muska**

⑧ Royal Space Force: The Wings of Honneamise, 1987

Director: Hiroyuki Yamaga
Runtime: 119 mins
Family-friendly factor: 1/5

A movie with big ideas and big vision, *Royal Space Force* is an original take on the coming-of-age story. It is set on an Earth-type planet, and follows the story of Shirotsugh Lhadatt, who joins the space programme in his native land. He befriends a deeply religious young woman, Riquinni Nonderaiko, and their story runs alongside his training and evolution.

There are plenty of different strands and the story evolves slowly, but it's an intriguing watch and the film asks many deep, interesting questions of its viewers. It is also superbly animated.

50 MUST-SEE ANIME MOVIES

"Civilization did not create war. War created civilization."

— **General Khaidenn**

ANIME MOVIES

"You're such a baby! Just grow up!"

— Satsuki

⑨ My Neighbor Totoro, 1988
Director: Hayao Miyazaki
Runtime: 86 mins
Family-friendly factor: 5/5

Possibly the most famous anime movie of them all, *My Neighbor Totoro* (see page 4) is a lovely story of two little girls who move house with their father, while their mother is in hospital recovering from an illness. It turns out that the house has some rather interesting forest-spirits living around it, and the girls make friends with them.

Stylistically, visually and sonically superb, the film is hugely entertaining, and offers a beautiful insight into Japanese history, culture and legend. Totoro lives in a camphor tree, he can't always be seen and he travels around in one of the most amazing sources of transport ever invented: the cat bus. If you haven't seen this movie yet, watch it tonight.

ANIME MOVIES

⑩ Grave of the Fireflies, 1988
Director: Isao Takahata
Runtime: 89 mins
Family-friendly factor: 2/5

Studio Ghibli hit a peak in 1988, with the release of both *My Neighbor Totoro* and *Grave of the Fireflies*. Both movies are amazing, but for very contrasting reasons. The lovely themes of nature and childhood innocence in *Totoro* are replaced with the treatment of the worst human events in *Grave of the Fireflies*.

Set in Japan at the end of World War II, *Fireflies* is the story of siblings Seita and Setsuko as they struggle to survive as orphans in this horrific period. It is powerful, beautiful and extremely moving – as well as very sad.

50 MUST-SEE ANIME MOVIES

"Why do fireflies have to die so soon?"

— Setsuko

ANIME MOVIES

⑪ Akira, 1988
Director: Katsuhiro Otomo
Runtime: 124 mins
Family-friendly factor: 3/5

Starting out as a manga, *Akira* was made as a long-form movie for release in 1988. Cinema-goers didn't quite know what had hit them, particularly if they weren't aware of the source material. Futuristic motorbike gangs, children with amazing powers, nuclear war, all with a soundtrack to give you a heart attack, *Akira* was like nothing that had come before it. It's an anime classic, a Japanese movie classic and a steampunk classic – and an utterly brilliant cinematic experience.

The influence that *Akira* exerted on subsequent movies and across all aspects of popular culture cannot be overstated; the movie broke new ground and paved the way for an entire phenomenon. It's no boast to say that this movie changed the world – just like Akira in the story.

"We only need to wait for the wind to blow and the fruit will fall into our hands. Wait for the wind called Akira!"

— Doctor Onishi

ANIME MOVIES

"We each need to find our own inspiration, Kiki. Sometimes it's not easy."

— Ursula

⑫ Kiki's Delivery Service, 1989
Director: Hayao Miyazaki
Runtime: 102 mins
Family-friendly factor: 5/5

Kiki's Delivery Service is part of the rich vein of form hit by Studio Ghibli and Hayao Miyazaki in the late 1980s. It is the lovely story of a young witch (and her black cat), which doubles up as a touching coming-of-age tale. It's got everything that Ghibli does best: young people overcoming adversity, food, flying machines, magic – and animals.

ANIME MOVIES

⑬ Only Yesterday, 1991
Director: Isao Takahata
Runtime: 118 mins
Family-friendly factor: 4/5

There is a tradition in anime of the reflective coming-of-age movie and *Only Yesterday* is one of the best. It is a beautiful tale about a young woman, Taeko, who takes a physical (and metaphorical) trip down memory lane when she visits her sister Nanako's in-laws in the country. She begins to reminisce about her childhood...

Only Yesterday is a lovely film: sweet, gentle, humorous and touching. Even learning about the annual safflower harvest is fascinating.

50 MUST-SEE ANIME MOVIES

"I didn't intend for ten-year-old me to come on this trip."

— **Taeko**

ANIME MOVIES

"There are warrants out on you for treason, illegal entry, decadence... and for being a lazy pig."

— Ferrarin

⑭ Porco Rosso, 1992
Director: Hayao Miyazaki
Runtime: 94 mins
Family-friendly factor: 4/5

Miyazaki was back once more in the director's seat for this one, in what is the first of his many flight-obsessed movies. Porco Rosso is an Italian fighter ace who just happens to have a pig's head (well, why not?). Set during World War I, *Porco Rosso* is an interesting tale of conflict, honour and – of course – love.

It's a fine story with plenty of action, some humour and many of the thought-provoking elements you'd expect from Studio Ghibli.

ANIME MOVIES

⑮ Ninja Scroll, 1993
Director: Yoshiaki Kawajiri
Runtime: 94 mins
Family-friendly factor: 2/5

Far from the cuddly Studio Ghibli releases and a long way from the techno-future so popular in many anime movies, *Ninja Scroll* is set in feudal Japan and is the action-packed, supernatural story of a lone ninja. There are plenty of twists and turns, and you'll be guessing motives and questioning alliances right up to the end: an absolute classic.

50 MUST-SEE ANIME MOVIES

"When I die, I'll take you to Hell with me!"

— Kibagami Jubei

ANIME MOVIES

⑯ Pom Poko, 1994
Director: Isao Takahata
Runtime: 119 mins
Family-friendly factor: 4/5

Pom Poko is a love-it-or-hate-it movie – there seems to be little in between. It is the story of a group of Japanese raccoon dogs (not racoons, whatever the subtitles say!) who find themselves forced to bring back the ancient art of metamorphosis in order to combat the human encroachment on their land.

It is by turns surreal, charming, funny, political and downright weird, but it is very entertaining, and provides a unique, big-balled (watch it to find out) insight into Japanese society, ecological issues and animal legends.

> "Not many people know this, but when humans aren't looking, all raccoons stand on two feet."
>
> — Narrator

ANIME MOVIES

"When the afternoon air currents mix, we can even touch the stars without fear!"

— Shizuku

⑰ Whisper of the Heart, 1995
Director: Yoshifumi Kondō
Runtime: 111 mins
Family-friendly factor: 5/5

The only movie Studio Ghibli animator Yoshifumi Kondō ever directed, *Whisper of the Heart* was based on a successful manga. It recounts the story of a young girl, Shizuku Tsukishima, a bookish sort who realizes all the books she has taken from the library have previously been taken out by the same person; she decides to find him.

The story is lovely, mixing fantasy and reality, and there are some truly touching moments (the musical scene is absolutely beautiful) and great characters (the Baron even got his own spin-off movie). One thing is guaranteed: you'll never listen to 'Take Me Home, Country Roads' the same way again.

ANIME MOVIES

⑱ Ghost in the Shell, 1995
Director: Mamoru Oshii
Runtime: 83 mins
Family-friendly factor: 1/5

Ghost in the Shell has been animated and filmed many times, with varying degrees of success. This version has grown in popularity since its first release and is now acknowledged as probably the best screen adaptation.

The "ghost" is the mind, the "shell" is the body. In the far-distant, tech-reliant future (2029!), hacking is everywhere. This sets the scene for a human/robot/cyborg sci-fi story. If you're a fan of *The Matrix* (ever wonder where the green number background came from?) or *Blade Runner* (similar future-noir vibes) and worried about the onset of AI (who isn't?), this one's for you. Cracking cinematography and an awesome soundtrack complete the treat.

> "You will bear our varied offspring into the Net, just as humans leave their genetic imprints on their children."

— Puppet Master

⑲ Memories, 1995
Directors: Kōji Morimoto ("Magnetic Rose"), Tensai Okamura ("Stink Bomb") and Katsuhiro Otomo ("Cannon Fodder")
Runtime: 113 mins
Family-friendly factor: 2/5

Actually made up of three short films in one feature-length release, *Memories* is a sci-fi/fantasy treat. There are three different stories by three different directors in three different styles. They are each individually brilliant – and the sum of all of them together is even more outstanding. Writing and animation are amazing, and the soundtracks, particularly in "Magnetic Rose", are sublime. These are a fantastic showcase of anime for anyone interesting in storytelling and movies.

50 MUST-SEE ANIME MOVIES

"Memories... Memories aren't an escape."

— **Heinz**

ANIME MOVIES

⑳ Princess Mononoke, 1997
Director: Hayao Miyazaki
Runtime: 133 mins
Family-friendly factor: 3/5

Yet another stone-cold classic from Studio Ghibli, *Princess Mononoke* has a lot going for it: strong female character, mystery, ambience, magic and amazing animation. It was the most popular film in Japan during the year of its release, and it held the country's box-office record until it was overtaken by Miyazaki's *Spirited Away* (see page 70).

The story is superb, with a strong environmental element – the conflict between man and nature is a central theme – and, although complicated, it is well worth the effort.

50 MUST-SEE ANIME MOVIES

"So you say you're under a curse? So what? So's the whole damn world."

— Jigo

ANIME MOVIES

"Nobody cares for you anymore. You're tarnished and you're filthy."

— Mima's ghost

㉑ Perfect Blue, 1997
Director: Satoshi Kon
Runtime: 81 mins
Family-friendly factor: 0/5

A very grown-up movie that walks the line between fantasy and reality, *Perfect Blue* deals with a young woman's descent into mental illness and is a great example of the extremes to which anime can take the viewer. With screenplay by Sadayuki Murai, this chilling tale features some very disturbing scenes. Best described as a slow-build, psychological horror movie, it is very well made and hauntingly effective. Don't let the J-pop theme and cute graphics fool you: this is a film for adults.

ANIME MOVIES

Takashi: "Why can't you all keep quiet like Nonoko?"

Noboro: "Uh, she's not here!"

㉒ My Neighbors the Yamadas, 1999
Director: Isao Takahata
Runtime: 104 mins
Family-friendly factor: 5/5

We are back to Studio Ghibli, but not as we have seen it before. *My Neighbors the Yamadas* is based on the famous manga of the same name and features a very different animation style from what the (Western) public had come to expect from Ghibli.

There's no real narrative – rather a series of comic-strip scenes about the amusing adventures of married couple Takashi and Matsuko Yamada, their son and daughter Noboru and Nonoko, Matsuko's mother Shige and the family dog, Pochi. It's light, it's fun, it's touching and it's good: great family entertainment.

ANIME MOVIES

㉓ Blood: The Last Vampire, 2000
Director: Hiroyuki Kitakubo
Runtime: 45 mins
Family-friendly factor: 0/5

Saya is a hunter of vampire creatures named Chiropterans. They mix with humans, feed on human blood and then hibernate, making it crucial to eliminate them whenever possible. It is 1966, and Saya is a schoolgirl. There's more to it, and the story unfolds in a haunting, violent manner, but ultimately this is a pulsing, stylish vampire movie, with some great twists and an interesting backdrop and characters. Stick with this version and don't bother with the live-action remake from 2009.

50 MUST-SEE ANIME MOVIES

"The orders from the top are to hunt them down no matter what."

— **David**

ANIME MOVIES

㉔ Vampire Hunter D: Bloodlust, 2000
Director: Yoshiaki Kawajiri
Runtime: 102 mins
Family-friendly factor: 1/5

In this book, vampire anime movies are like buses – nothing for ages and then two turn up at once. The year 2000 was a good one for vampires as *Vampire Hunter D: Bloodlust* came out. It is very different from *Blood: The Last Vampire*, not least because of its setting, which is in the distant future (although it has more of a hi-tech western feel). Telling the story of D, a *dhampir* (vampire/human cross), it features fights, strange creatures, even stranger humans and lots of blood – vampire movie essentials. It is beautiful, fascinating, dark and strange. The movie is based on the hugely popular book characters by Hideyuki Kikuchi.

50 MUST-SEE ANIME MOVIES

"When the last vampire is extinct, who will mourn our passing?"

— Meier Link

ANIME MOVIES

㉕ Cowboy Bebop: The Movie, 2001
Director: Shinichirō Watanabe
Runtime: 115 mins
Family-friendly factor: 2/5

Cowboy Bebop: The Movie is closely linked to the *Cowboy Bebop* anime series and uses many of the same crew and actors. It is, in turn, based on the hugely successful *Cowboy Bebop* manga. The basic story in all three is this: the Bebop is a spaceship manned by bounty hunters in the year 2071, a time when humans have colonized other planets.

The movie story involves a plot to wipe out an entire planet's population (on Halloween!) and the Bebop crew's efforts to stop this happening. It's deeper than it sounds, with some great moments, strong characters and superb cinematography.

50 MUST-SEE ANIME MOVIES

"I'm just a gun-toting weathergirl."

— **Faye**

ANIME MOVIES

"My fate seems to be tied to earthquakes."

— Chiyoko Fujiwara

㉖ Millennium Actress, 2001
Director: Satoshi Kon
Runtime: 87 mins
Family-friendly factor: 3/5

The director that made the harrowing *Perfect Blue* (see page 57), Satoshi Kon, is back with another helping of what's-real-what-isn't, in his unique style. This multi-layered movie tells the story of a documentary film that's being made about a famous actress, Chiyoko Fujiwara, who suddenly quit the movie scene 30 years previously. A tale of leaving, loving and searching ensues.

It is a beautiful story that unfolds slowly and carefully (not to mention confusingly!), and the multiple layers (reality, dreams, movies), symbols and concepts are blended together masterfully. A truly captivating, unique film.

㉗ Metropolis, 2001
Director: Rintaro
Runtime: 113 mins
Family-friendly factor: 3/5

Set, as you would imagine, in a huge, futuristic city, *Metropolis* is a big movie with a big story and big ideas. It owes its origins to the Fritz Lang silent-movie classic with the same name, although there's not really any story sharing.

It involves Rock, the adopted son of city bigwig Duke Red, whose job it is to destroy malfunctioning or errant robots (think *Blade Runner*). Another storyline involves a Japanese private detective's nephew, Kenichi, whose path crosses with Rock, and the introduction of Tima, a super advanced robot who is indistinguishable from a human. A descent through the bowels of the city follows. *Metropolis*, in all its sprawling glory, is a genuine visual treat, with absolutely fantastic visuals and thoughtful themes.

> "I am an artificial human. A machine created to conquer the world and destroy it."

— **Tima**

28. Spirited Away, 2001
Director: Hayao Miyazaki
Runtime: 125 mins
Family-friendly factor: 4/5

Before *Spirited Away*, anime had a largely cult following and had even made it into a few bigger cinemas with movies such as *Akira* and *My Neighbor Totoro*. But *Spirited Away*, with its Academy Award win and subsequent fame and fortune, brought anime into the mainstream. Looking at it now, it's a pretty odd movie: Chihiro and her parents are on a road trip and stop off for a walk to explore an overgrown funfair. Her parents are transformed into pigs, and Chihiro gets stuck on the wrong side of a river. The rest of the film is an amazing, beautiful journey around some fairly indescribable places, creatures and events.

Spirited Away is a magical, dreamlike fairy-tale adventure. If you only watch one of the movies mentioned in this book, make sure it's this one.

"I promise I'll be back, Haku. You can't die."

— Chihiro

㉙ Tokyo Godfathers, 2003
Director: Satoshi Kon
Runtime: 92 mins
Family-friendly factor: 2/5

Pretty much acknowledged as "the one that got away" because it is such a good movie but isn't all that well known, *Tokyo Godfathers* is a Christmas tale from the master of mystery Satoshi Kon. It tells the story of three homeless people in Tokyo, who find an abandoned baby on Christmas Eve and decide to reunite the child with its parents. This being a movie by Kon, what ensues is anything but straightforward (although this is more straightforward than his other movies!), but it is thrilling, entertaining and touching – with a backdrop and supporting cast of Tokyo lowlife and nightlife.

"This is a Christmas present from God! She's our baby!"

— Hana

ANIME MOVIES

"Your head's like a turnip. I've always hated turnips."

— Sophie

㉚ Howl's Moving Castle, 2004
Director: Hayao Miyazaki
Runtime: 119 mins
Family-friendly factor: 4/5

Another superb outing for Studio Ghibli, *Howl's Moving Castle* is a surreal, fantastic, fun adventure. Loosely based on the fantasy novel by Diana Wynne Jones, it is the story of Sophie, who has been transformed into an old woman by a witch. Against a backdrop of war, she strives to change back, aided by Howl, a wizard she meets, and his crew.

Howl's Moving Castle is a brilliant, beautiful adventure, populated by fantastic characters (Calcifer the fire demon anyone?), a superb plot and a strong anti-war theme (Miyazaki was very angry about the invasion of Iraq). Studio Ghibli does it again.

ANIME MOVIES

"Y'know, I've been meaning to tell you: you've got no taste."

— Atsu

㉛ Mind Game, 2004
Director: Masaaki Yuasa
Runtime: 103 mins
Family-friendly factor: 0/5

As you may guess from the title, this isn't really a straightforward movie with a distinct linear narrative. It is, however, a thought-provoking piece of original – very adult – moviemaking.

Rather than reading the "plot" (although there is one), you really need to watch it: seeing is believing. There's an incredible variety of animation styles and techniques, lovely colour and a great soundtrack. And there may be a happy ending... Well, there's some sort of ending after the pulsing, mind-melting, acid-trip rollercoaster ride of the previous 100 minutes.

㉜ The Girl Who Leapt Through Time, 2006
Director: Mamoru Hosoda
Runtime: 98 mins
Family-friendly factor: 3/5

Relatively straightforward by anime standards, *The Girl Who Leapt Through Time* is, as you'd hopefully guess, the story of a girl who is able to travel through time. It's a high-school student, Makoto, who gains the ability to jump through eras, but only a limited number of times. This is a neat take on the time-travel theme, and is skillfully made, dealing well with young romance and its associated complications. There's a dubbed English-language soundtrack version available too.

50 MUST-SEE ANIME MOVIES

"If a guy is late meeting up with you, you're the type to go run and look for him, right?"

— Kazuko

㉝ Ponyo, 2008
Director: Hayao Miyazaki
Runtime: 101 mins
Family-friendly factor: 5/5

Yet another lovely, magical tale from Miyazaki and Studio Ghibli, *Ponyo* is the story of a fish-girl, Brunhilde, who befriends a human boy, Sōsuke. She transforms into a human and lives with Sōsuke and his mother. However, the magic she used causes an imbalance in nature, with potentially devastating effects...

The character Ponyo is funny, thoughtful and cheeky and the movie matches her well. The young characters' view of the world is brilliantly realized, making this one of the all-time greats. *Ponyo* was a huge, global success – put it on your watch list.

50 MUST-SEE ANIME MOVIES

"Mom! Ponyo came back, and she's a little girl now!"

— Sōsuke

ANIME MOVIES

㉞ Mai Mai Miracle, 2009
Director: Sunao Katabuchi
Runtime: 93 mins
Family-friendly factor: 3/5

Mai Mai Miracle is the story of a young girl, Shinko, and what happens to her in a small village in the Japanese countryside in the 1950s. Her "mai mai" (a cowlick on her forehead) enables her to see the past vividly, as well as letting her show others. Most of the movie is quite gentle, a sweet look back at innocent times, but there are darker themes explored too. A curious mixture, *Mai Mai Miracle* looks lovely, and carries an interesting message.

"It's something I imagined, so only I can see it."

— Shinko

ANIME MOVIES

"Mr President, we can't let Funky Boy destroy Roboworld."

— Roboworld Advisor

㉟ Redline, 2009
Director: Takeshi Koike
Runtime: 102 mins
Family-friendly factor: 2/5

You may think that an animated movie about racing cannot live up to a live-action equivalent. Think again, for *Redline* is a pulsing action movie that races to its finish line – the opening sequence alone will have you on the edge of your [race-car] seat. It's a thrilling sci-fi story, with a great cast and a love story buried underneath. It's a fast, frenzied ride into a crazed future, and it's great fun – really well made too, although definitely one for the videogame generation. After watching it, you feel like you've been immersed in a game for weeks.

ANIME MOVIES

㊱ Arrietty, 2010
Director: Hiromasa Yonebayashi
Runtime: 95 mins
Family-friendly factor: 5/5

Based on the 1952 novel *The Borrowers* by Mary Norton, *Arrietty* is Studio Ghibli's take on the story of the tiny humans ("borrowers") who live in people's houses. In this version, Shō, a young man, remembers a special week he spent in the house "where my mother grew up". There, he meets Arrietty the borrower, and learns of her world.

This is a multi-generational tale, sweet and moving, and featuring the brilliant animation the world had come to expect from Studio Ghibli. The English and the American dubbed versions each feature all-star casts to good effect.

"Children can be more terrifying than grown-ups."

— Homily

ANIME MOVIES

㊲ From Up on Poppy Hill, 2011
Director: Gorō Miyazaki
Runtime: 92 mins
Family-friendly factor: 4/5

An outstanding example of the gentler side of anime, *From Up on Poppy Hill* (see page 6) is a slow-build drama that tells the story of Umi, a young girl in high school. She meets Shun, and a fascinating story unfolds, both tender and exciting, as the past comes back to affect the future.

Ostensibly a coming-of-age tale, the underlying themes are darker than the film seems, but *From Up on Poppy Hill* works on various levels and for many age groups, and bears up really well to repeat viewing.

50 MUST-SEE ANIME MOVIES

"There's no future for people who worship the future, and forget the past."

— Shun Kazama

㊳ Wolf Children, 2012
Director: Mamoru Hosoda
Runtime: 117 mins
Family-friendly factor: 3/5

Just when you think you couldn't be anymore surprised by the contents of an anime movie, up pops this one. *Wolf Children* is not like any other anime, and certainly not like any other werewolf movie. It's more a reflection on how difficult it is to be different, whether that involves turning into a ferocious beast or dealing with social services. (It can also be fun!)

Wolf Children works so well because it is so, well, um, human, in its outlook; simply the story of a young mother overcoming hardship. Oh, and even for a book about incredible animation, the animation is incredible; an exhilarating experience.

"Why is the wolf always the bad guy?"

— Ame

ANIME MOVIES

㊴ The Tale of the Princess Kaguya, 2013
Director: Isao Takahata
Runtime: 137 mins
Family-friendly factor: 5/5

A really stylish animated version of a famous Japanese fairy story, *The Tale of the Princess Kaguya* is a glorious movie. The story is simple: a bamboo cutter finds a tiny little girl in a bamboo shoot and raises her as his own. Funnily enough, it turns out she's not your average child…

As always with Studio Ghibli at its best, the story features multiple layers, and the subtext about belonging and finding one's place in (any) society is subtly dealt with. It's lovely and brilliant, with varying, sweeping animation styles that lend it an almost immersive feel.

50 MUST-SEE ANIME MOVIES

"Birds, bugs, beasts/ Grass, trees, flowers/ Teach me how to feel."

— **The Princess Kaguya (singing)**

"Airplanes are beautiful dreams. Engineers turn dreams into reality."

— Caproni

㊵ The Wind Rises, 2013
Director: Hayao Miyazaki
Runtime: 126 mins
Family-friendly factor: 5/5

A curio in the pantheon of Studio Ghibli, this is a fictionalized biopic of the aeronautical engineer Jiro Horikoshi. The movie's events take place in Japan between the two world wars and are themselves based on the novel, *The Wind Has Risen*, by Tatsuo Hori. This mixture of fact, semi-fact and fiction gives the film a basis in reality that is rare in Studio Ghibli's output, but serves to demonstrate that a good story is a good story, regardless of whether it is based on scientific principles, witchcraft or magic. And Studio Ghibli excels in all three.

ANIME MOVIES

"Kanta. Let's go home together. Back to Japan."

— Junpei

㊶ Giovanni's Island, 2014
Director: Mizuho Nishikubo
Runtime: 102 mins
Family-friendly factor: 3/5

Despite its strong links to *Night on the Galactic Railroad* (see page 26), *Giovanni's Island* is very much a stand-alone film. Themes of the past, war, remembrance and humanity pervade, in a tragic, moving story that unfurls in the aftermath of World War II. On a Japanese island occupied by Russian soldiers, brothers Junpei and Kanta live with their grandfather, and when the Red Army takes over, their lives become intertwined with Tanya, the daughter of the commander.

This is a triumph of gentle storytelling with a grim backdrop. *Giovanni's Island* is an excellent film.

㊷ When Marnie Was There, 2014
Director: Hiromasa Yonebayashi
Runtime: 103 mins
Family-friendly factor: 5/5

Anna Sasaki (Anna in the 1967 novel *When Marnie Was There* by Joan G. Robinson) is unwell and sent to a seaside town to stay with her foster mother's relatives. She meets a girl in a supposedly abandoned house, and they make friends. An engrossing, haunting story follows, with coincidences, tragedy and family links.

When Marnie Was There is a beautifully recounted ghost story – to classify it as anything – but it, like all the best movies, does not fit simply into any one category. It is appealing to all ages: a touching, mysterious and moving tale.

"You're my precious secret. I haven't told anyone about you, and I won't."

— Marnie

43 Your Name, 2016
Director: Makoto Shinkai
Runtime: 107 mins
Family-friendly factor: 4/5

Your Name is a very special movie. Watch it once and you'll discover a superb, dramatic, mind-melting tale of body-swapping crossed with a time-travelling dramatic disaster movie. Watch it twice and you will start to pick up on subtle strands in any one of those significantly different genres. Watch it three times and you should start to really appreciate the complex web of events and emotions that is spun by the makers. Quite simply, *Your Name* is a really good watch.

High-school students Mitsuha (in Itomori) and Taki (in Tokyo) intermittently swap bodies with each other for a day at a time. Taki thinks he's falling for Mitsuha and so he tries to call her but cannot get through. The body-swapping stops, but the mystery really begins, and doesn't let up until the very end of this fascinating movie: jump in and have fun!

50 MUST-SEE ANIME MOVIES

"If we see each other, we'll know. That you were the one who was inside me. That I was the one who was inside you."

— Mitsuha

㊹ A Silent Voice, 2016
Director: Naoko Yamada
Runtime: 130 mins
Family-friendly factor: 3/5

At first glance, it's "just another" coming-of-age movie, but *A Silent Voice* has a lot more going for it. It deals expertly with themes of bullying, belonging, loneliness and friendship, telling a tough story on the way.

Shōko is a school student who was born deaf, and who is bullied by a group of kids, including Shōya. He is eventually transferred to another school, where his reputation precedes him, but he embarks on a journey of redemption. It's a tough watch sometimes, and hard to make sense of for Western audiences who may be unused to seeing what is perceived as childish imagery dealing with such grown-up issues. But not only is it amazing to look at, it handles its difficult themes really well.

"I want to love a person, even a monster has a heart..."

— Shōya

ANIME MOVIES

"I don't understand why Liz would do it. Set the bird free."

— Mizore

㊺ Liz and the Blue Bird, 2018

Director: Naoko Yamada
Runtime: 90 mins
Family-friendly factor: 4/5

A wonderfully crafted movie, *Liz and the Blue Bird* was previously filmed as a television series (after the novels), but this big screen treatment stands alone.

It is the story of two young friends and musicians, Mizore and Nozomi, who are practising for a high-school concert. A fairy tale (called "Liz and the Blue Bird") is told in parallel, from a book that one of them owns. There is significant musical accompaniment.

The ins and outs of Mizore and Nozomi's relationship is examined in detail, and parallels are drawn with the characters in the story, with help from their fellow students. It's a gentle journey but a rewarding one, and it's rare to enjoy such detail in any movie.

㊻ Weathering with You, 2019
Director: Makoto Shinkai
Runtime: 112 mins
Family-friendly factor: 3/5

One of the top grossing anime movies of all time, *Weathering with You* was a global hit when it came out. Following the success of *Your Name* (see page 100), director Shinkai began working on this new movie based on a story he wrote himself.

A convoluted love story that involves a whole lot more than a simple boy-meets-girl narrative, *Weathering with You* is best experienced rather than anticipated. It is a sumptuous treat for the senses, showcasing the best anime has to offer.

50 MUST-SEE ANIME MOVIES

"Who cares if we can't see any sunshine? I want you more than any blue sky."

— **Hodaka**

ANIME MOVIES

㊼ Demon Slayer: Kimetsu no Yaiba – The Movie: Mugen Train, 2020
Director: Haruo Sotozaki
Runtime: 119 mins
Family-friendly factor: 2/5

I'm going to be honest: *Demon Slayer* (for short) made it into this book for only one reason: it is the biggest grossing Japanese movie ever. Pulling in half a billion dollars (and counting), and outperforming amazing movies such as *Your Name*, *Spirited Away* and, um, *The First Slam Dunk*, it cannot be ignored.

As you may have guessed, *Demon Slayer* is about a demon slayer. In this case, his name is Tanjiro Kamado, who, along with his sidekicks Inosuke (who wears a boar's head) and Zenitsu (the cowardly one), kick some demon butt. There's no accounting for taste, and you never know, *Demon Slayer* may be just what you are looking for...

50 MUST-SEE ANIME MOVIES

"No matter how many lives the demons take, one thing they can never crush is a human's will."

— Kagaya Ubuyashiki

ANIME MOVIES

㊽ Suzume, 2022
Director: Makoto Shinkai
Runtime: 122 mins
Family-friendly factor: 4/5

Another Shinkai outing, this one is based around the story of Suzume, a high-school girl who meets a young man, Souta, who it turns out is a "closer" – and we're not talking real estate. He has to shut doors between the Earth and another dimension to prevent a monster from entering. If you find that hard to swallow, wait until a cat turns him into a three-legged chair. Despite what you may be thinking, this is a great movie, with epic chases, clever characters and interesting plot twists. Does Souta get turned back into a human? You'll have to watch it to find out...

> "The worm comes through the gate. Thank you for helping me. Now forget everything you saw here and go home."
>
> — Souta

ANIME MOVIES

"Shoot me! My heart is right here, but you've only got one arrow. So don't miss!"

— The Grey Heron

㊾ The Boy and the Heron, 2023
Director: Hayao Miyazaki
Runtime: 124 mins
Family-friendly factor: 4/5

Miyazaki's triumphant return to the big screen – and reputedly his final outing – won Studio Ghibli another Oscar, repeating *Spirited Away*'s Best Animated Feature Film accolade.

The Boy and the Heron is a sumptuous fantasy journey of the imagination and features many Studio Ghibli/Miyazaki trademarks: young person dealing with loss, talking animals, fantastic places and beasts, surreal events and so on. It's the story of Mahito, a young boy coping with the death of his mother while dealing with a distant father and a preoccupied aunt-turned-stepmother.

It's very good – maybe not *great* – but well worth watching.

㊿ My Oni Girl, 2024
Director: Tomotaka Shibayama
Runtime: 112 mins
Family-friendly factor: 3/5

Not your average high-school boy-meets-girl flick, *My Oni Girl* has the protagonist, Hiiragi, meet up with what turns out to be a demon. Fortunately for him, she's a rather nice demon, and is seeking her mother as part of an effort to find her place in the world. Hiiragi has similar problems fitting in, so the two get on like a house on fire – or rather ice (there are a lot of snow demons).

A rather odd love story, *My Oni Girl* offers a look into the Japanese national psyche and the core elements of belonging, whether you're a demon or a simple school kid. It's a fascinating watch.

50 MUST-SEE ANIME MOVIES

"Tsumugi… You, uh, seem to have grown a horn."

— Hiiragi

★ ★ ★ ★ ★

DIRECTORS'
CUT

ANIME MOVIES

"I can't stand modern movies. The images are too weird and eccentric for me."

— Hayao Miyazaki,
The Independent, 2009

DIRECTORS' CUT

Hayao Miyazaki (1941–)

Renowned animator, filmmaker and manga artist, Miyazaki (see page 116) was born in Tokyo City and is cofounder of Studio Ghibli. His international breakthrough came with *Princess Mononoke* in 1997, which was followed by *Spirited Away*, frequently ranked among the greatest films of the 21st century. His themes often relate to nature and technology, nonviolence and the importance of craftsmanship. Known for his meticulous animation style and strong, independent female characters, his legacy has shaped global animation.

ANIME MOVIES

Hiromasa Yonebayashi (1973–)

Born in Ishikawa, the animator and film director joined Studio Ghibli in the 1990s, making his directorial debut with *Arrietty*. With Yoshiaki Nishimura, he cofounded the animation group Studio Ponoc in 2015, with the Serbo-Croatian word *pónoć*, meaning "midnight" and signifying "the beginning of a new day".

DIRECTORS' CUT

Isao Takahata (1935–2018)

One of Japan's greatest filmmakers and a cofounder of Studio Ghibli, Takahata was born in Mie Prefecture, Japan, and died in Tokyo. Exploring themes of human vulnerability, deep emotion, nature and social issues, his films had a profound influence on Hayao Miyazaki.

Katsuhiro Otomo (1954–)

The manga artist, animator and film director was born in Miyagi Prefecture. He is known for balancing realism and fantasy, and taking manga beyond the confines of gekiga and sports to sci-fi territory. He is considered one of the New Wave of manga artists from the 1970s and 1980s and influenced Japanese video game design.

Makoto Shinkai (1973–)

Born in Nagano, Shinkai initially worked as a graphic designer before transitioning into filmmaking. He gained international acclaim with *Your Name* in 2016, which became one of the highest-grossing anime films of all time. His works, including *Weathering with You*, 2019, and *5 Centimeters per Second*, 2007, often explore themes of love, distance and the passage of time.

ANIME MOVIES

Mamoru Hosoda (1967–)

Born in Toyama, Hosoda explores themes of family, personal growth and the intersection of technology with human experience in his films. His distinctive visual style and storytelling approach have earned him international recognition. A former animator at Toei Animation, Hosoda founded Studio Chizu in 2011.

DIRECTORS' CUT

Naoko Yamada (1984–)

Best known for her work with Kyoto Animation, Yamada was born in Kyoto Prefecture. She began her career as an animator before rising to prominence as a director. Her style is characterized by its emotional depth, subtle storytelling and character-driven narratives. Yamada's work has earned her a reputation as one of the most distinctive voices in contemporary Japanese animation.

Satoshi Kon (1963–2010)

Manga artist, filmmaker and animator, Kon is noted for blending surrealism with psychological and emotional depth. His work often features intricate narratives and innovative animation techniques. Kon had a unique ability to merge the boundaries between the real and the imagined.

DIRECTORS' CUT

Yoshiaki Kawajiri (1950–)

A writer, director, storyboard artist and animator, Kawajiri was born in Kanagawa Prefecture. He gained prominence in the 1980s and 1990s for his stylized direction in action-packed, often violent, adult-oriented anime. His work frequently blends cyberpunk, horror and fantasy elements, with fluid animation and mature themes.

ANIME MOVIES

"I've always wanted to have a haunted house. It's been my lifelong dream!"

— Tatsuo Kusakabe,
My Neighbor Totoro